# CONTENTS

# METRIC CONVERSION TABLES

## Solids

An exact conversion from imperial to metric measurements is totally impractical for cooking purposes, the equivalent of 1 ounce being 28.35 grams. The following table provides a satisfactory basis for converting recipes; although the metric equivalents are about 10% above the imperial measurements, the proportions are retained.

| OUNCES | GRAMS | OUNCES | GRAMS |
|--------|-------|--------|-------|
| 1 | 30 | 9 | 280 |
| 2 | 60 | 10 | 315 |
| 3 | 90 | 11 | 345 |
| 4 | 125 | 12 | 375 |
| 5 | 155 | 13 | 410 |
| 6 | 185 | 14 | 440 |
| 7 | 220 | 15 | 470 |
| 8 | 250 | 16 | 500 |

## Liquids and Cup Measures

The 8-fluid ounce (227 ml.) measuring cup will be replaced by a standard 250-millilitre metric measuring cup. The comparative imperial and metric graduations are set out below:

| IMPERIAL | | METRIC | |
|----------|-----|--------|-----|
| fl. oz. | cup | cup | ml. |
| 1 | | | 30 |
| 2 | $\frac{1}{4}$ | $\frac{1}{4}$ | |
| | $\frac{1}{3}$ | $\frac{1}{3}$ | |
| 3 | | | 100 |
| 4 | $\frac{1}{2}$ | $\frac{1}{2}$ | |
| 5 ($\frac{1}{4}$ pt.) | | | |
| 6 | $\frac{3}{4}$ | $\frac{3}{4}$ | |
| 8 | 1 | 1 | 250 |

The metric teaspoon is 5 ml., and the tablespoon 20 ml. (15 ml. in New Zealand); the imperial ones are equivalent to 3.6 ml. and 14.2 ml. respectively.

# INTRODUCTION

This is a collection of typical Scottish recipes from the majestic Highlands and pastoral Lowlands; both wholesome family cooking and the festive fare for which Scotland is famed are well represented.

Many Scottish recipes are of French origin. Indeed, James I is said to have employed a French cook; while, in the time of Mary Queen of Scots, so much money was spent on foreign sweetmeats that Parliament passed a law forbidding all but the rich to have anything on their table that was not made in Scotland.

It is well known that Scottish housewives take a traditional pride in setting a good table. I hope you will enjoy these recipes gathered together over the years, and remember the words of Scotland's best loved poet, Robert Burns:

> *Some hae meat that canna eat,*
> *and some wad eat that want it,*
> *But we hae meat, and we can eat,*
> *And sae the Lord be thankit.*

3

# SOUPS

Good stock is essential for good soup. Stock can be made from shin of beef, marrow bones, bacon bones, knuckles of veal, shanks of mutton, neck, or sheep's heads.

## SCOTCH BROTH

| | |
|---|---|
| 1 neck of mutton | 1 large cup diced turnip |
| 3 oz. dried peas | 1 onion |
| 3 oz. pearl barley | 1 leek |
| 2 qt. water | ¼ white cabbage, shredded |
| salt and pepper | 1 large cup grated carrot |
| 1 large cup diced carrot | 1 tbsp. chopped parsley |

Soak peas overnight. Wash meat, put into a stockpot with water, peas, barley, salt, and pepper. Bring to the boil and skim. Add the diced carrot, turnip, chopped onion and leek, and simmer for 3 hours. Add shredded cabbage and grated carrot, and simmer for another half an hour. Before serving, add parsley.
Serves 6-8

# LENTIL SOUP

| | |
|---|---|
| 1 qt. stock made from 1 lb. bacon bones or 4 oz. bacon | 1 small turnip, diced |
| | 1 stalk of celery, chopped |
| 6 oz. lentils | salt and pepper |
| 1 cup diced carrot | chopped parsley |
| 1 cup diced onion | |

Bring stock to the boil, wash the lentils, and add to the stock. Add the diced carrot, onion, turnip, and chopped celery. Season to taste and simmer in a covered saucepan for 2 hours. Before serving, decorate with chopped parsley.

Lentil soup can be varied by sieving and returning to the pan with $\frac{1}{4}$ pint of milk. If desired, the soup can be thickened with 1 tablespoon of flour blended with a little milk.

Serves 4-6

# TATTIE (POTATO) SOUP (1)

| | |
|---|---|
| 2 lb. potatoes | salt and pepper |
| 1 large or 2 small onions | 1 dsp. flour |
| 2 stalks of celery | $\frac{1}{4}$ pt. milk |
| 1 oz. dripping | parsley |
| 1 qt. beef stock | |

Peel and dice potatoes, chop onion and celery. Melt fat in a saucepan and fry vegetables for about 10 minutes. Add beef stock, salt, and pepper. Bring to the boil, cover, and simmer until vegetables are tender. Mash with potato-masher. Blend flour with milk and add to soup to thicken. Decorate with parsley before serving.

Serves 6

# TATTIE (POTATO) SOUP (2)

2 lb. diced potatoes
2 carrots, diced
1 turnip, diced
2 leeks, chopped
salt and pepper

3 pt. beef stock made from
   2 lb. marrow bones
1 cup grated carrot
parsley

Add diced carrot and turnip, chopped leeks, and seasoning to stock in a large saucepan. Bring to the boil and simmer, covered, for 1 hour. Add diced potatoes and grated carrot and simmer for another hour. Garnish with finely chopped parsley.

Serves 6

# TOMATO SOUP

2 lb. tomatoes
1 carrot
1 onion
1 qt. stock from bacon
   bones or 8 oz. pork

2 tbsps. sago
½ pt. milk
salt and pepper

Skin tomatoes by soaking for a short time in boiling water. Cut up tomatoes, carrot, and onion. Put into a saucepan, cover with stock, and season. Bring to the boil, add sago and cook for 30 minutes. Rub through a sieve and return soup to pan. Add milk and heat through gently—do not boil.

Serves 4

# NETTLE BROTH

2 cups chopped young
   nettles
1 qt. chicken stock

½ cup barley
1 cup diced potatoes

Wash nettles and chop finely. Boil chicken stock
and barley in a saucepan for 1 hour. Add the nettles
and potatoes. Cover and simmer until all ingredients
are tender. Serve hot.

Serves 4

## HARICOT BEAN SOUP

| | |
|---|---|
| 12 oz. haricot beans | 1 turnip, diced |
| 3 pt. beef or bacon stock | 1 lb. diced potatoes |
|    made from 2 lb. marrow | salt and pepper |
|    bones or 2 lb. bacon | 1 tbsp. flour |
|    bones | ½ pt. milk |
| 2 small onions, diced | parsley |

Wash beans and soak overnight. Put into a sauce-
pan with stock, diced vegetables, salt, and pepper.
Bring to the boil and simmer, covered, for about 2
to 2½ hours, or until beans are tender. Force through
a sieve and return soup to pan. Blend the flour with
a little of the milk and stir into soup. Add remain-
ing milk and reheat. Before serving, sprinkle with
finely chopped parsley.

Serves 6-8

## BARLEY BROTH

| | |
|---|---|
| 1 neck of mutton | 1 cup diced carrot |
| 8 oz. barley | 1 cup diced turnip |
| ½ cup dried peas | 2 leeks, chopped |
| 3 pt. (approximately) | 2 stalks of celery, chopped |
|    water | parsley |
| salt and pepper | |

Soak peas overnight. Wash the neck of mutton and

the barley. Put in a saucepan and cover with water. Add salt and pepper. Bring to the boil and simmer, covered, for 1½ hours. Add all the vegetables and cook for another hour, adding more water if required. Add chopped parsley about 10 minutes or so before broth is ready.

Serves 6

## BAREFIT BROTH

| | |
|---|---|
| 1 cup barley | 1 lb. potatoes |
| 3 carrots | ¼ cabbage, chopped |
| 3 onions | 3 pt. water |
| 2 stalks of celery | salt and pepper |
| 2 small turnips | parsley |

Dice carrots, onions, celery, turnips, and potatoes. Roughly chop cabbage. Place all vegetables and barley in a large saucepan with water and seasoning and boil steadily for 1½ hours. Garnish with parsley.

Serves 6

## DRIED PEA SOUP

| | |
|---|---|
| 8 oz. dried peas | 1 qt. stock made from |
| 1 onion | bacon bones |
| 1 small turnip | salt and pepper |
| 1 carrot | parsley |
| 1 oz. dripping | |

Wash peas and soak overnight. Dice all other vegetables and fry lightly in dripping. Add the stock, peas, and seasoning. Cover and simmer for 2½ hours. Serve garnished with parsley.

Serves 4-6

# SPLIT PEA SOUP

1 qt. stock made from 1 lb. bacon bones or a small piece of pork
8 oz. split peas
½ cup diced carrot
½ cup diced turnip
½ cup chopped onion
salt and pepper

Bring the stock to the boil, then add the split peas, which have been washed. Now add the diced carrot, turnip, and chopped onion. Season with salt and pepper. Cover and simmer for 2 hours.

Serves 4-6

# OXTAIL SOUP

1 oxtail
2 oz. cooking fat
2 cups diced carrot
1 cup diced turnip
1 large onion, sliced
3 pt. stock
salt and pepper

Coarsely chop oxtail and wash well. Melt fat in a saucepan and fry vegetables for about 4 minutes. Add the stock, oxtail, salt, and pepper. Bring to the boil, cover, and simmer gently for 3 hours. Take out the oxtail and remove the meat with a fork. Return meat to the soup. If desired, thicken with 1 tablespoon of flour blended with stock. Serve hot.

Serves 6

# CHICKEN SOUP

2 lb. boiling fowl
1 onion
3 pt. water
salt and pepper
5 oz. rice
1 cup diced carrot
parsley

Wash pieces of fowl and slice onion. Put into a saucepan with the water and seasoning. Bring to the boil, cover, and simmer for 2 hours; you may need to add more water during this time. Now add the rice and diced carrot and simmer for another hour. Skim fat from surface. Remove pieces of fowl and separate the meat from the bones. Put meat into a tureen and pour the soup over. Garnish with parsley.

Serves 6

## COCK-A-LEEKIE

| | |
|---|---|
| 1 cock or boiling fowl | salt and pepper |
| 2 qt. beef stock made from | prunes (optional) |
|    shin or marrow bones | |
| 2 bunches leeks | |
|    (approximately 2 lb.) | |
|    washed and chopped | |

Place fowl in a saucepan, cover with stock, and add chopped leeks, salt, and pepper. Bring to the boil and simmer, covered, for 4 hours. Skim fat from surface. Half an hour before soup is ready, add a handful of prunes and continue simmering. When soup is ready, remove the cock or fowl and cut in pieces. Put meat in a tureen and pour the soup over.

Serves 6-8

## POWSOWDIE (Sheep's Head Broth)

| | |
|---|---|
| 1 sheep's head | 3 medium carrots |
| 1 flank of mutton | 3 medium onions or leeks |
| 1 cup barley | 3 small turnips |
| 1 cup dried peas | 3 stalks of celery |
| salt and pepper | parsley |

Soak the head overnight in lukewarm water. Remove the eyes. Split the head and lay aside the brains. Clean the head thoroughly. Put head and mutton in a large saucepan and cover well with water. Add the barley, soaked peas, and seasoning. Bring to the boil and keep boiling for $1\frac{1}{2}$ hours. Skim fat from the surface. Dice all the remaining vegetables, add to the pan, and boil slowly for another 2 hours. Garnish with parsley.

Serves 6-8

# FISH

When buying fish, be sure that the eyes are bright and clear. If the fish is not fresh, the eyes will be dull and sunken. If it is fresh, it will float when placed in a bowl of water.

## CABBIE CLAW

| | |
|---|---|
| 1 lb. cod fillets | 1 level dsp. cornflour |
| 1 lb. good quality potatoes | ½ tsp. dry mustard |
| 2 oz. butter | 1 hard-boiled egg |
| ½ pt. milk | 3 oz. grated cheese |
| salt and pepper | |

Cook the potatoes, then drain and slice them. Place the cod fillets in a frying pan with the butter and the milk and seasoning. Simmer gently until fish is cooked. Blend the cornflour and the mustard with a little of the milk. Add to the fish, shaking the pan gently over the heat until the sauce thickens. Turn into a casserole. Chop the egg and sprinkle over the fish. Add the potatoes, and top with the grated

cheese. Cook in a hot oven (425°) for 15 minutes.
Serves 4

## SALMON

In the late 19th century, when Scotland's rivers were teeming with salmon, this fish was given to the servants while the gentry ate sole, cod, haddock, and so on. Times have changed.

### Boiled Salmon

Scale and clean fish, then place on a rack in a saucepan or wrap in a piece of muslin so that it can be easily removed from the pan. Simmer in boiling water to which salt, 1 dessertspoon of vinegar, and 1 tablespoon of olive oil have been added. Allow 10 minutes to each pound of salmon and 10 minutes over. May be served hot or cold. Garnish with slices of lemon, parsley, or cucumber.

### Baked Salmon

Wrap the fish tightly in buttered foil, so that no moisture can escape. Place in a tin and bake in a moderate oven, allowing 20 minutes per pound for the first 3 pounds and 10 minutes for each pound over. To serve cold, allow to cool in foil. Serve with salad.

(Mullet can be baked in the same way.)

## CREAMED FINNAN HADDIE

*1 Finnan haddock (1-1½ lb.)*

Soak the fish for 1 hour in enough milk to cover.

Bring slowly to the boil in the milk and simmer for 20 minutes. Drain, keeping some of the stock for sauce. Flake the fish, removing the skin and bones, then set aside while making the sauce.

**Sauce:** Melt 2 tablespoons of butter in a frying pan, remove from heat and blend in 2 tablespoons of flour. Mix in $\frac{1}{2}$ cup of milk and $\frac{1}{2}$ cup of stock from fish, and $\frac{1}{4}$ teaspoon of salt. Return to the heat and cook for 1 minute without browning. Add liquid slowly, stirring all the time. Bring to the boil and cook for a few minutes. Pour sauce over fish and garnish with chopped parsley, chives, or a chopped, hard-boiled egg. May be sprinkled with lemon juice.

Serves 3-4

## POACHED GOLDEN FILLET

*1 lb. golden fillet*

Wash the fish and remove tail and fins. Put into a saucepan with a piece of butter and cover with milk. Season to taste with salt and pepper. Simmer gently for 6 minutes. Make sauce as for Creamed Finnan haddie.

This fish may also be fried in butter.

Serves 2-3

## HERRINGS IN OATMEAL

*6 fresh herrings*      *salt and pepper*
*6 oz. oatmeal*         *fat for frying*

Split and bone the herrings and wash well. Mix a teaspoonful of salt with the oatmeal. Coat the

herrings on both sides with the oatmeal. Have frying pan ready, with the fat smoking, and put herrings in, skin side uppermost. Fry the fish for 3 minutes on each side. Drain on absorbent paper. Serve with mashed potatoes and peas.

(Tommy Ruffs can be cooked in the same way.)
Serves 3-4

## KIPPERS

Wash fish in cold water. Remove heads, small fins, and tail. Brush fish with butter or margarine and bake, grill, or fry for about 5 minutes, or until the backbone begins to rise.

To prevent smell when baking, wrap in aluminium foil.

*Note:* Kippers can now be bought boneless in 1-pound packets.

## BROOK TROUT

Clean and wash the fish. Cut off the tail and fins, but leave the heads on. Dip fish in seasoned flour and fry in butter until tender. Serve with wedges of lemon or tomato and chopped parsley.

Can be served cold with salad.

*Note:* An angler would consider it sacrilege to cook trout in this way. According to him, you should build a fire of sticks at the side of the burn and make a grill of sticks across it to place the fish on. Cook the fish on both sides, turning only once, and eat it with the fingers, washing it down with a drink of whisky and spring water.

## FISH CAKES

| | |
|---|---|
| 1 lb. cooked fish | salt and pepper |
| ½ pt. thick white sauce | egg |
| 1½ lb. mashed potatoes | breadcrumbs |
| chopped parsley | dripping |

Cream the fish with the sauce. Add the mashed potato, parsley, salt, and pepper. Shape into cakes, dip into beaten egg and breadcrumbs and fry in hot fat till golden brown.

Serves 4-6

## CURLED WHITING

Wash the fish and remove the eyes. Curl the fish around and put the tail through the eye socket. Brush with butter or margarine, season, and sprinkle with breadcrumbs. Place in a greased tin and bake in a moderate oven for half an hour. Garnish with parsley and lemon wedges.

## FRIED FILLET OF SOLE

Dip fish in beaten egg and coat with breadcrumbs. If using deep fat, fry the fish in a basket, and drain well before serving. If cooking in shallow fat, turn on both sides. Serve with lemon wedges.

Sole can also be baked, steamed, poached, or grilled with butter.

# MEAT DISHES

### HAGGIS

> *Fair fa' your honest, sonsy face,*
> *Great chieftain o' the puddin' race!*
> *Aboon them a' ye tak your place,*
> *Painch, tripe or thairm;*
> *Weel are ye worthy of a grace*
> *As lang's my arm.*

Robert Burns, *To a Haggis.*

This dish is served on Burns' Anniversary, 25 January, and St Andrew's Day, 30 November, carried aloft on a silver tray by a highlander in full Highland dress, preceded by a piper playing a national air.

| | |
|---|---|
| 1 stomach bag | 8 oz. shredded mutton |
| liver, lights, and heart of | suet |
| a sheep | salt |
| 1 breakfast cup oatmeal | black pepper |
| 2 onions | |

Clean stomach bag thoroughly and leave over-night in cold water to which salt has been added. Turn rough side out. Put heart, lights, and liver in a pan. Bring to the boil and simmer for 1½ hours. Toast the oatmeal on a tray in the oven or under the grill. Chop the heart, lights, and liver. Mix all the ingredients together with the suet, adding salt and pepper. Keep mixture sappy, using the liquid in which the liver was boiled. Fill bag a little over half full, as mixture needs room to swell. Sew securely and put in a large pot of hot water. As soon as mixture begins to swell, prick with a needle to prevent bag from bursting. Boil for 3 hours.

Serve with mashed potatoes and mashed turnip. Serves 6-8

## BOILED GIGOT (Leg of mutton)

In pre-war days when the steamers sailed "doon the watter" from the Broomielaw, Glasgow, the dinner menu usually included Scotch broth and Boiled gigot.

| | |
|---|---|
| 1 leg of mutton | 6 small young carrots |
| salt and pepper | 6 small young turnips |

Wash the mutton well. Put into a saucepan and cover with water. Bring slowly to the boil, then skim the surface and add salt and pepper. Do not put a fork or anything sharp into the meat as this will drain the juices. Boil for 1 hour with the lid on, add whole young carrots and turnips and cook for another hour. To serve, garnish with the carrots and turnips and serve with Caper sauce.

The stock in which the gigot has been boiled can be used for Barley broth or Scotch broth.

## Caper Sauce

| | |
|---|---|
| 1 oz. margarine | 1 dsp. chopped capers |
| 1 oz. flour | 1 tsp. vinegar |
| ½ pt. milk | salt and pepper |

Melt the margarine, stir in the flour, and cook for 1 minute without browning. Add the milk a little at a time, stirring well. Add the capers, vinegar, salt and pepper, and cook for 2 to 3 minutes.

Serves 6

## SCOTS MUTTON PIES
### Pastry

| | |
|---|---|
| 4 oz. dripping | 1 lb. flour |
| ½ pt. water | ½ tsp. salt |

### Filling

| | |
|---|---|
| 12 oz. lean mutton | beaten egg |
| 1 small onion, chopped | gravy |
| salt and pepper | |

**Pastry:** Make the pastry by putting dripping and ½ pint of water in a saucepan. Bring to the boil. Sieve flour and salt. Make well in the centre and pour in the hot liquid. Mix to a dough with a knife, then knead on a floured board till free of cracks. Cut off a quarter of the pastry and keep it warm. Line six small tins or shape some cases round the base of a glass.

**Filling:** Cut the mutton into small pieces and mix

with the chopped onion. Add the seasoning. Use a little stock to moisten and fill the pies. Put on the lids, wetting the edges and sticking them firmly together. Make a hole in the top of each. Brush the pies with a little beaten egg. Bake in a moderate oven for 40 minutes. Serve hot, filling them up with a little hot gravy.

Serves 3

## STUFFED SHOULDER OF MUTTON

| | |
|---|---|
| 1 shoulder of mutton | salt and pepper |
| 4 oz. fresh breadcrumbs | a little nutmeg |
| 1 oz. shredded suet | 1 egg, beaten |
| 1 level dsp. mixed herbs | |
| 1 level dsp. chopped parsley | |

Have the butcher remove the bone from the shoulder.

Mix the breadcrumbs, suet, herbs, parsley, salt, pepper, and nutmeg with the beaten egg. Fill the shoulder of mutton with the seasoning and roll up tightly. Tie with string at 1-inch intervals or sew up. Place in baking tin and cook in a moderate oven, (350° to 375°), allowing 30 minutes for each pound. Serve with buttered carrots, roast potatoes, and red-currant jelly.

## BOILED SHEEP'S TONGUES

| | |
|---|---|
| 6 tongues | 2 cloves |
| 1 qt. water | 1 blade of mace |
| 1 dsp. vinegar | |

Wash the tongues well. Put water, vinegar, cloves,

and mace into a saucepan and bring to the boil. Add the tongues. Simmer gently for 2½ to 3 hours. Remove skins and cut in half lengthways. Serve with salad.

Serves 6

## FRIED LIVER AND BACON

    1 lamb's fry or 1 lb. baby       2 oz. dripping
        beef liver                    6 bacon rashers
    2 oz. plain flour seasoned        parsley
        with salt and pepper

Wash liver, dry it and cut into ½-inch slices. Dip in seasoned flour. Fry the bacon in dripping, then add the liver, turning several times, and cook gently. Serve on a hot dish with bacon on top. Garnish with parsley.

Serves 3 to 4

## HIELAN' STEAK

    4 fillet steaks                   2 tbsps. whisky
    2 oz. butter                      3 oz. Cheddar cheese
    2 tbsps. cream                    parsley or watercress

Fry steak on both sides in melted butter until cooked. Remove from pan. Pour cream and whisky into pan and heat gently. Pour over steaks. Garnish with grated cheese and parsley or watercress.

Serves 4

## BEEF STEW WITH HARICOT BEANS

This was, at one time, a very popular Sunday morning breakfast dish in the mining districts of Scotland.

| | |
|---|---|
| 1½ lb. stewing steak | 2 tbsps. dripping |
| 2 oz. seasoned flour | 1½ pt. stock |
| 3 young carrots | 1 cup haricot beans |
| 2 onions | soaked overnight |

Cut up the meat and dip in flour. Peel and chop carrots and onions. Fry the meat in dripping with the carrots and onions until browned, then remove and cook remaining flour until it is browned. Gradually add stock, stirring constantly to make a smooth, thick gravy. Add meat, vegetables, and beans and simmer until meat and beans are tender, approximately 2 hours.

Serves 4-6

## FORFAR BRIDIES

| | |
|---|---|
| 12 oz.-1 lb. topside steak | 1 lb. shortcrust pastry |
| salt and pepper | 3 oz. shredded suet |
| 1 small onion, chopped | |

Cut the meat into small pieces, season with salt and pepper. Add the chopped onion. Divide mixture into three portions. Make a stiff dough with flour and water and roll out thinly into three ovals. Cover half of each with meat, suet, and onion. Wet round the edges and crimp together, making a hole on top. Bake in a quick oven (about 400°) for 30 minutes. Serve hot.

Serves 3

## POTTED HOUGH

This dish is very popular in the Highlands of Scotland.

3 lb. hough or shin of
beef
1 knee bone or knuckle
bone

salt and pepper

Wash the hough and the bone. Place both in a saucepan with water to cover and add salt and pepper. (If desired, spices such as a bay-leaf, a blade of mace, allspice, or nutmeg may be added.) Cover and simmer gently for 6 hours. Remove bones and meat from saucepan. Mince the meat as small as possible with a fork. Put meat back in pan, adding more water to cover, if necessary. Boil for 10 minutes. Leave to cool, then turn into a wetted mould.

Serve with salad in summer.

Serves 6-8

## SHEPHERD'S PIE

1 lb. cooked mince
1 small onion, chopped
2 oz. butter
1 cup stock, made from
beef stock cube

salt and pepper
2 lb. boiled potatoes
1 egg

Heat mince. Fry onion until golden brown in 1 ounce of butter. Add to mince, then stir in stock and seasoning. Place in a greased pie-dish. Mash potatoes, with the rest of the butter, then add beaten egg. Beat well. Cover mince with the potatoes and bake in a moderate oven for 15 minutes. Dot potato with butter and brown under grill after cooking.

Serves 4

## MINCED COLLOPS

1 oz. dripping
1 large onion, finely chopped
1 lb. minced steak
1 cup beef stock

salt and pepper
½ cup breadcrumbs (or 1½ dsps. oatmeal)

Melt dripping in a pan and add chopped onion. Cook for a couple of minutes, then add the minced steak. Brown steak, beating it well with a fork to keep free from lumps. Add the stock and about a teaspoonful of salt and pepper to taste. Simmer for 1 hour, then add a handful of breadcrumbs or, for variation, a handful of oatmeal. Cook for a few minutes more. Serve with mashed potatoes and buttered carrots.

Serves 4

## MORAY PIE

1 lb. minced steak
2 oz. butter
3 small carrots, grated
3 small onions, chopped

½ pt. beef stock or water
salt and pepper
1 lb. potatoes

Fry the mince in the butter until brown, then add the grated carrots and chopped onions and fry gently for another 2 minutes. Add the stock and seasoning. Simmer for 30 minutes. Parboil the potatoes and cut into slices about ¼ inch thick. Put the meat mixture into a pie-dish and top with the sliced potatoes. Brush with melted butter and brown under grill. Garnish with parsley.

Serves 4

# MEAT ROLY-POLY

| | |
|---|---|
| 8 oz. self-raising flour | 1 cup cold water |
| 3 oz. shredded suet | 1 lb. cooked mince with |
| ½ tsp. salt | onion |

Mix the dry ingredients and add cold water to give a soft dough. Roll out thinly on a floured board. Drain the mince, putting aside the gravy. Spread the mince on the pastry, leaving ½ inch at each end. Roll up pastry and seal by wetting the edges. Place on a greased baking tray and bake in a moderate oven (350° to 375°) for 45 minutes. Slice and serve with the gravy from the mince.

Serves 4

# SCOTCH EGGS

| | |
|---|---|
| 5 eggs | breadcrumbs |
| 1 lb. sausage-meat | dripping |

Boil four of the eggs until hard and beat the other. Shell cooked eggs, dip in the beaten egg, and cover with the sausage-meat. Dip in beaten egg again, then in breadcrumbs. Fry in deep fat for 10 minutes. Drain on absorbent paper.

Serve hot with chip potatoes, and green peas, or, if served cold, halve crosswise and serve with salad.

Serves 4

# SAUSAGE ROLLS

| | |
|---|---|
| 8 oz. flaky or shortcrust pastry | a little beaten egg or milk |
| 12 oz. sausages or sausage-meat | |

If using sausages, dip them in cold water, and remove skin. Roll pastry out thinly on a floured board and cut into pieces to wrap around the sausages. Put a sausage or roll of sausage-meat in each. Roll up and damp edge of pastry to seal. Make three cuts on top of each roll. Place the rolls on a baking-tin and brush with milk or beaten egg. Place near the top of a hot oven (425°), and cook for 20 minutes.

Makes 8 to 10 rolls.

## ABERDEEN SAUSAGE
This recipe comes from Aberdeen, the Granite City.

| | |
|---|---|
| 1 lb. sausage meat | 1 tbsp. Worcestershire |
| 1 lb. minced steak | sauce |
| 4 oz. minced bacon | salt and pepper |
| 8 oz. fresh white | 1 egg, beaten |
| breadcrumbs | breadcrumbs for coating |

Mix together all ingredients, except the last two. Bind with beaten egg. Make into a roll. Boil in a floured cloth for 1½ hours. Roll in breadcrumbs, toasted in the oven. Serve cold with salad.

Serves 6

## TRIPE AND ONIONS

| | |
|---|---|
| 1½-2 lb. prepared tripe | 1 pt. milk |
| 4 large onions | 1 oz. cornflour |
| salt and pepper | chopped parsley |
| 1 oz. butter | |

Wash the tripe and cut in small pieces. Peel and slice the onions. Put the tripe, seasoning, and onions in a saucepan and cover with water. Bring to the boil and simmer gently for 2½ hours. Add the butter and most of the milk, keeping a little back to blend with the cornflour. Heat gently and stir in cornflour. Bring to the boil, stirring until thick. Garnish with parsley before serving.

Serves 4

## OXTAIL STEW

| | |
|---|---|
| 1 oxtail | 2 small onions |
| 2 oz. plain flour | salt and pepper |
| 2 oz. dripping | 1½ pt. beef stock or water |
| 2 small carrots | |

Wash tail well and dry it. Cut into joints and trim off any excess fat. Dip in flour. Melt fat in saucepan and fry meat till brown. Lift out meat and lightly fry sliced carrots and onions. Put meat back into the saucepan, add seasoning and stock or water. Simmer for 3 hours.

Serves 4

## PICKLED PORK

| | |
|---|---|
| 2-3 lb. piece of pickled pork | 3 small onions |
| | 3 young carrots |

Wash the meat. Prepare the vegetables, leaving them whole. Put into saucepan of water with the meat, bring to the boil, and simmer until the meat is tender. Remove meat and cut the string. Serve with the cooked vegetables and Pease pudding.

## Pease Pudding

> 6 oz. yellow split peas     salt and pepper
> 1 oz. butter

Wash peas and leave to soak overnight in cold water. Drain off the water and tie them loosely in a piece of muslin, leaving room for them to swell. Put in a saucepan of boiling water and simmer gently for 3 hours. Lift from pan and turn into a bowl. Beat in the butter and salt and pepper until the pudding is smooth.

## ROAST CAPERCAILZIE

> 2 young hen birds     4 oz. middle bacon rashers
> salt and pepper     2 knobs of butter

Season inside of birds with salt and pepper and add the knobs of butter. Tie pieces of bacon over the breasts. Put in roasting tin in a moderate to hot oven (375° to 400°) for 45 minutes, basting frequently. Serve with cranberry sauce, peas, and chip potatoes.

## TIGHNABRUAICH RABBIT STEW

> 1 rabbit     2 oz. dripping
> 1 oz. flour, seasoned with     1 pt. stock, made from
>     salt and pepper     1 lb. marrow bones or
> 2 onions     beef stock cube
> 3 young carrots

Wash rabbit well and leave overnight in lightly salted cold water. Cut in pieces and dip each piece in seasoned flour. Clean and chop vegetables and fry with the rabbit till lightly browned. Remove from

pan, draining well, and place in a casserole with stock. Cover and simmer till meat is tender.

Serves 4

## KINGDOM OF FIFE PIE

| | |
|---|---|
| *1 young rabbit* | *2 tbsps. white wine* |
| *1 lb. pickled pork* | *puff pastry* |
| *salt and pepper* | *egg glazing (1 egg beaten* |
| *nutmeg* | *with a little milk)* |
| *1 cup gravy made from* | |
| *Liver forcemeat balls* | |

Cut rabbit in pieces and steep for an hour in cold water. Cut the pickled pork in pieces and season with salt, pepper, and nutmeg. Make gravy and Liver forcemeat balls (see below).

Put rabbit, pork, and forcemeat balls into a pie-dish. Add gravy and white wine. Cover with thinly rolled pastry and brush the top with egg glazing. Make holes for ventilation. Bake in a moderate oven (350° to 375°) for $1\frac{1}{4}$ to $1\frac{1}{2}$ hours. Serve hot or cold with potatoes and other vegetables.

Serves 6

### Liver Forcemeat balls

| | |
|---|---|
| *liver* | *salt and pepper* |
| *1 rasher of bacon* | *nutmeg* |
| *$\frac{1}{4}$ cup breadcrumbs* | *beaten egg* |

Mince the liver and rasher of bacon. Mix with the breadcrumbs, a pinch of salt and pepper, and a shake of nutmeg. Bind with beaten egg and form in balls.

Makes six.

# HARE CASSEROLE

| | |
|---|---|
| 1 young hare | 3 small onions, sliced |
| 4 oz. bacon | 1 bay-leaf |
| 2 tbsps. butter | 2 peppercorns |
| 2 oz. flour | salt and pepper |
| 1 pt. beef stock | 2 glasses port |

Cut hare into small pieces and bacon into thin strips; mix them together. Melt the butter and fry the meat until brown, then transfer to a casserole. Stir in the flour and add the stock, onions, herbs, and seasoning. Cover tightly and cook in a slow oven (300°) for about 3 hours. Remove lid, add the wine, and cook until the liquid thickens. Serve with creamed potatoes.

Serves 4

# VENISON

Venison should be hung for 2 weeks in a cool place where there is a good circulation of air. Wipe it every day with a dry cloth, to remove any moisture, then dust with pepper. Venison is inclined to be a little dry, so, before cooking, rub the joint all over with butter or lard and wrap in foil. Bake in a moderate oven (375°), allowing 25 minutes for each pound, plus an extra 25 minutes. Serve with cranberry sauce or a thin gravy.

# PHEASANT CASSEROLE

| | |
|---|---|
| 1 pheasant | a little claret or port |
| 2 oz. plain flour | 3 bacon rashers |
| 2 oz. butter | salt |
| ½ pt. stock | black pepper |

Joint the bird and dip in flour. Heat the butter in a frying pan and fry the pieces of pheasant until they are golden brown. Put into a casserole with the stock, wine, chopped bacon, and the seasoning. Cook in a moderate oven (350° to 375°) for 1 hour. Garnish with parsley and serve with chip potatoes and green peas.

Serves 3

# SCONES, BANNOCKS, and PANCAKES

## EDINBURGH SCONES

This recipe comes from the capital, with its lovely Princes Street and floral clock.

| | |
|---|---|
| *10 oz. self-raising flour* | *2 oz. butter* |
| *2 tsps. baking powder* | *½ cup currants* |
| *¼ tsp. salt* | *1 egg* |
| *1 dsp. sugar* | *milk* |

Mix together dry ingredients, then rub in butter and add fruit. Combine egg and milk and add to dry mixture, to form a soft dough. Knead on a lightly floured board. Roll out and cut into ½-inch thick rounds. Bake in the oven at 450° for 10 minutes.

## GIRDLE SCONES

| | |
|---|---|
| *10 oz. self-raising flour* | *1-2 oz. butter or margarine* |
| *½ tsp. salt* | *milk* |

Sift flour and salt, rub in butter. Add milk and

mix to a soft dough. Place on a floured surface, knead very lightly, and roll out to $\frac{1}{4}$-inch thickness. Cut into triangles and place on a greased and floured, moderately hot girdle or heavy-based frying pan. When scones are brown, turn them and cook on other side.

## SOUR MILK SCONES

| | |
|---|---|
| 2 oz. butter or margarine | 1 lb. self-raising flour |
| 1 egg | $\frac{1}{2}$ tsp. salt |
| $\frac{1}{2}$ pt. buttermilk | 1 dsp. sugar |

Melt the butter or margarine, beat egg and add both to buttermilk, mixing well together. (If buttermilk is not available, add juice of $\frac{1}{2}$ lemon to $\frac{1}{2}$ pint of milk and let stand for 1 hour before using.) Add dry ingredients and mix to a soft dough. Turn out on to a floured surface and knead very lightly. Cut off pieces of the dough and flatten with the hand. Prick with a fork. Bake in a hot oven (400°) for 10 to 15 minutes.

*Note:* The secret of success with scones is to knead the dough as little as possible.

## TREACLE SCONES

| | |
|---|---|
| 8 oz. plain flour | $\frac{1}{2}$ tsp. ground ginger |
| 2 oz. butter | a pinch of salt |
| $\frac{1}{2}$ tsp. baking soda | 1 tbsp. treacle |
| $\frac{1}{2}$ tsp. cream of tartar | milk |
| $\frac{1}{2}$ tsp. cinnamon | |

Rub the butter into the flour. Add the soda,

cream of tartar, cinnamon, ginger, and salt. Mix thoroughly. Melt the treacle with a little milk. Stir into flour mixture, adding just enough milk to make a firm dough. Knead lightly on a floured board. Roll out to ¾-inch thickness and cut into triangular pieces. Bake in a greased tin in a hot oven for 10 to 15 minutes.

## POTATO SCONES

    *1 lb. mashed potatoes*    *4 oz. (approximately)*
    *salt*                      *plain flour*

Mash potatoes until quite smooth, adding a little salt. Knead with flour to required thickness. Cut into triangles. Brown both sides on a girdle or frying pan, pricking with a fork to prevent blistering. Serve hot, spread with butter.

## SPECIAL POTATO SCONES

    *¼ cup oatmeal*       *1 lb. potatoes*
    *2 oz. plain flour*    *salt*

Mash potatoes, then add a little salt and the oatmeal. Knead in as much flour as mixture will take up. Roll out very thinly and cut into triangles. Prick all over with a fork. Brown on a girdle or frying pan, turning once. Serve hot, spread with butter.

*Note:* The secret of light scones is to bake them while the potatoes are still hot.

## PITCAITHLY BANNOCKS

    *4 oz. butter*             *a pinch of salt*

| | |
|---|---|
| 3 oz. castor sugar | 1 oz. mixed peel or |
| 6 oz. plain flour | orange peel |
| 1 oz. rice flour or ground | 1 oz. finely chopped |
| rice | blanched almonds |

Cream butter and sugar together thoroughly. Work in the flours and salt, then add the chopped, mixed peel and almonds. Make into a cake about 1 inch thick. Pinch the edges with finger and thumb. Place on a greased baking tin lined with grease-proof paper. Prick all over with a fork and bake in a moderate oven (350° to 375°) for 30 to 35 minutes. Cool on a wire rack.

## ARDENTINNY DROP BANNOCKS

| | |
|---|---|
| 1 egg | a pinch of salt |
| 1 pt. milk | oatmeal |
| ¼ tsp. baking soda | |

Beat the egg in a large bowl and stir in milk. Mix in the baking soda, salt, and enough oatmeal to make a dropping batter. Now put the mixture in a jug. Rub the girdle or frying pan with fat and pour batter into small rounds. Cook over moderate heat until bubbles form, then turn and cook other side. Serve spread with butter and honey.

## SCOTCH PANCAKES

| | |
|---|---|
| 8 oz. plain flour | 2 oz. sugar |
| ½ tsp. baking soda | 2 eggs |
| 1 tsp. cream of tartar | milk |

Mix dry ingredients. Then stir in beaten eggs and

enough milk to make a batter with the consistency of thick cream. Place spoonfuls of mixture on a hot, greased girdle or frying pan and turn pancakes when bubbles burst. When cooked, keep them warm in a cloth. Serve with butter, jam, and cream.

## OATMEAL PANCAKES

| | |
|---|---|
| 4 oz. plain flour | ½ tsp. cinnamon |
| 4 oz. oatmeal | a pinch of salt |
| 2 oz. sugar | 1 egg |
| ½ tsp. baking soda | milk |
| 1 tsp. cream of tartar | |

Mix dry ingredients. Make a well in the centre and add the beaten egg. Mix well. Gradually stir in milk until mixture is the consistency of thick cream. Place spoonfuls of mixture on a hot girdle or frying pan. Cook until golden brown on one side, and then turn. Serve hot with butter and jam.

# CAKES and BISCUITS

*"Health to the Chieftains and clans;
and God Almighty bless the Land of
Cakes."*

H. M. George IV
Edinburgh, 1822

## BLACK BUN

Black Bun is an extremely rich cake that Scots
the world over hanker for at Hogmanay. It should
be made a few weeks before the New Year and kept
in an air-tight tin.

### Pastry

| | |
|---|---|
| 2 cups plain flour | water |
| a pinch of salt | 1 tsp. baking powder |
| 6 oz. butter | |

Sift the flour with the salt. Rub in the butter. Stir
in baking powder and enough water to make a firm
dough. Roll out very thinly and line a greased,

37

9-inch square cake tin, reserving enough pastry to cover the top.

## Fruit Mixture

| | |
|---|---|
| 1 lb. currants | ½ tsp. baking soda |
| 1 lb. raisins | a pinch of salt |
| 1 lb. sultanas | ½ tsp. pepper |
| 4 oz. chopped peel | ½ tsp. ground nutmeg |
| 4 oz. butter | 1 dsp. cinnamon |
| 2 oz. sugar | 1 dsp. mixed spice |
| 3 eggs | ½ tsp. ground ginger |
| 1 cup plain flour | ½ tsp. ground cloves |
| 1 tsp. cream of tartar | 2 oz. chopped almonds |

Cream together butter and sugar. Beat in eggs, one at a time. Sieve flour, cream of tartar, baking soda, and salt into the mixture. Add spices, floured fruit, and chopped almonds. Mix well. Fill the pastry-lined tin with the mixture, place pastry on top. Moisten edges and press together. Crimp edges. Bake slowly for 3 hours at 300°.

*Note:* Rich fruit cakes should always be cooked in the centre of the oven.

## SCOTCH CURRANT BUN
### Pastry

| | |
|---|---|
| 4 oz. butter | ½ tsp. baking powder |
| 7½ oz. plain flour | water |

Rub the butter into flour and baking powder. Mix with water to a firm paste. Grease a 9-inch square cake tin and line neatly with pastry, reserving enough to cover the top.

**Fruit Mixture**

| | |
|---|---|
| 1 lb. plain flour | ½ oz. cinnamon |
| 8 oz. sugar | ½ oz. allspice |
| 2 lb. large seeded raisins | ½ tsp. black pepper |
| 2 lb. currants | 1 tsp. baking powder |
| 4 oz. orange peel | 1 tsp. cream of tartar |
| 4 oz. chopped almonds | ½ pt. milk, or enough to |
| ½ oz. ginger | moisten mixture |

Mix all ingredients together thoroughly with
your hands and put mixture into a lined tin. Flatten
the top, and wet the edges all around with milk. Put
lid on top, prick with a fork, and brush with egg.
Bake slowly for 3 hours at 300°.

*Note:* This cake improves with keeping.

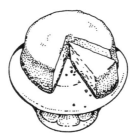

## SULTANA CAKE

| | |
|---|---|
| 12 oz. plain flour | 4 oz. mixed peel |
| 1 tsp. baking powder | 8 oz. butter |
| a pinch of salt | 8 oz. sugar |
| 1 lb. sultanas | 5 eggs |

Grease an 8-inch cake tin and line with grease-proof paper. Sieve dry ingredients. Wash and dry sultanas and chop peel. Add to the flour. Cream butter and sugar and beat in eggs one at a time. Mix in the dry ingredients. Add a little milk, if necessary, to give a soft consistency. Bake in a moderate oven for 2 hours.

## DUNDEE CAKE

| | |
|---|---|
| 1½ lb. mixed fruit | 8 oz. sugar |
| 6 oz. mixed peel | 4 eggs |
| 8 oz. self-raising flour | 1 dsp. lemon juice |
| a pinch of salt | 3 oz. blanched almonds |
| 8 oz. butter | |

Grease and line an 8-inch cake tin. Prepare fruit and chop peel. Sieve the flour and salt. Cream butter and sugar and beat in one egg at a time. Mix in the flour, fruit, peel, lemon juice, and 1 ounce of chopped, blanched almonds. Put mixture into cake tin. Arrange remaining almonds on top and bake in a moderate oven for 2 hours or until firm to the touch.

## ISLAY LOAF

| | |
|---|---|
| 6 oz. raisins | 10 oz. sifted self-raising |
| 6 oz. brown sugar | flour |
| ½ pt. cold water | 2 tsps. baking soda |
| 1 tbsp. golden syrup | 1 dsp. mixed spice |
| 1 tbsp. butter | ¼ cup chopped walnuts |

Boil together raisins, sugar, water, golden syrup, and butter. Allow to cool, then fold in flour, soda, spice, and walnuts. Bake in a greased and lined

8-inch cake tin in a moderate oven (350° to 375°) for 1 hour.

## SEED CAKE

Traditionally, seed cake is served on "Auld Handsel" Monday (the first Monday of the New Year).

| | |
|---|---|
| 6 oz. self-raising flour | 1 tsp. Scotch whisky |
| 1 tsp. baking powder | 4 oz. butter |
| 1 tbsp. caraway seeds | 4 oz. sugar |
| 2 eggs | |

Mix together flour, baking powder, and caraway seeds. Beat eggs and whisky together. Cream butter and sugar; add the well beaten eggs and flour mixture. Pour into an 8-inch tin, greased and lined, and bake for three-quarters of an hour at 350°.

## HAMILTON GINGERBREAD

| | |
|---|---|
| 6 oz. butter | 1 tsp. baking soda |
| 6 oz. brown sugar | dissolved in a little |
| 6 oz. treacle | water |
| 1 lb. self-raising flour | milk |
| 2 tsps. powdered ginger | |

Cream together butter, sugar, and treacle. Sieve together the flour and ginger. Stir into treacle mixture, together with baking soda and enough milk to make a soft, dropping consistency. Pour into a 10-inch square, well-greased and lined shallow cake tin. Bake at 350° for 1½ hours or until firm to the touch. When cold, cut into squares.

## MONTROSE CAKES

8 oz. butter
8 oz. castor sugar
6 eggs, well beaten
8 oz. self-raising flour

6 oz. currants
1 level tsp. nutmeg
2 tbsps. brandy

Cream butter and sugar. Add beaten eggs gradually, and then sieved flour, currants, nutmeg, and brandy. Beat for 20 minutes. Put into small, buttered patty tins and bake in a hot oven (400°).

## PERKINS

4 oz. plain flour
2 oz. butter or margarine
4 oz. fine oatmeal
3 oz. castor sugar
1 level tsp. baking soda

½ tsp. cinnamon
½ tsp. ground ginger
¼ tsp. mixed spice
3 level tbsps. syrup
1 oz. blanched almonds

Prepare a greased baking sheet. Sieve flour and rub in the butter. Mix in all the other ingredients except the almonds and syrup. Mix to a firm dough with the syrup. Spoon pieces the size of a walnut on to baking sheet, leaving room to spread, and flatten them with a fork. Place half an almond on each. Bake in a moderate oven (350° to 375°) for 10 minutes, or until crisp. Cool on a wire rack.

## BROWNIES

4 oz. butter or margarine
4 oz. brown sugar
1 egg

6 oz. self-raising flour
1 tbsp. cocoa
3 oz. chopped walnuts

Cream the butter and sugar. Add the egg and beat

well. Mix in the flour, cocoa, and chopped walnuts.
Put a tablespoon at a time on a greased tray and bake
in a moderate oven (350°) for 20 minutes.

## BUTTERSCOTCH MERINGUES

*2 egg-whites*  
*⅓ tsp. cream of tartar*  
*a pinch of salt*

*4 oz. soft brown sugar*  
*½ cup chopped walnuts*

First, prepare the tray on which the meringues are
to be baked. Rub a few drops of oil over the tray,
then dust with flour. Tip the tray and give it a
sharp knock, so that only a light dusting of flour
is left on the surface.

Beat the egg-whites with the cream of tartar and
salt until stiff. Stir in brown sugar, 1 tablespoon at a
time, beating until stiff after each addition. Fold
in chopped walnuts. Heap in rounds on prepared
tray and bake in a very slow oven (155°) for 1 to 1½
hours. Remove immediately from tray. When cold,
put together with cream.

## OATCAKES

*8 oz. oatmeal*  
*a good pinch of salt*  
*¼ tsp. baking soda*

*1 dsp. melted fat (butter*  
*or lard may be used)*  
*hot water*

Put oatmeal in a bowl and add salt and baking
soda. Make a well in centre and pour in melted fat.
Blend in enough hot water to make a stiff paste, then
knead and roll out as thinly as possible. Cut into
triangles and bake on a floured tin in a moderately
hot oven (400°), until the ends curl up and cakes are

crisp (20 to 30 minutes). Alternatively, bake them on a hot girdle or frying pan. Serve with butter, honey, or marmalade.

## OATIES

| | |
|---|---|
| 4 oz. plain flour | 2 oz. castor sugar |
| 2 level tsps. baking powder | 3 oz. treacle |
| ½ level tsp. salt | 4 oz. butter |
| 4 oz. rolled oats | some coarse oatmeal |

Sieve together flour, baking powder, and salt, then add rolled oats. Put sugar, treacle, and butter into a saucepan and heat until just melted. Mix this into the flour until all ingredients are combined. Press into a 7-inch, greased sandwich tin and bake for 20 minutes at 350°. Sprinkle with coarse oatmeal. Cut into wedges before the mixture cools.

## TANTALLON BISCUITS

| | |
|---|---|
| 4 oz. plain flour | 4 oz. sugar |
| 4 oz. rice flour or ground rice | 2 eggs |
| a pinch of baking soda | 2 or 3 drops vanilla or lemon essence |
| 4 oz. butter | |

Sieve together flours and baking soda. Cream the butter and sugar, beat the eggs, and add alternately with the flours to the creamed mixture. Flavour with vanilla or lemon essence. Roll out thinly. Cut into rounds and bake on a greased baking sheet for 30 minutes in a fairly hot oven (400°). Dust with castor sugar. Cool on a wire rack.

## ABERNETHY BISCUITS

8 oz. plain flour  
½ tsp. baking powder  
3 oz. butter  
3 oz. castor sugar  

1 tsp. caraway seeds  
1 beaten egg  
milk  

Sift the flour and baking powder into a bowl. Rub in the butter, then stir in the sugar and caraway seeds. Mix with the beaten egg and enough milk to make a stiff dough. Turn on to a floured board and roll out thinly. Cut into rounds and prick centres with a fork. Bake on a greased baking sheet in a moderate oven (375°) for about 10 minutes.

## CADZOW BUTTER BISCUITS

8 oz. plain flour  
½ tsp. salt  

4 oz. butter  
cold water  

Sift flour and salt into a bowl. Work butter in lightly with the fingertips. Mix to a firm dough with cold water. Roll out to 1/8-inch thickness. Prick with a fork and cut into rounds. Place a little apart on a greased tray and bake in a moderate oven (350°) until golden brown. Cool on a wire rack. Spread with butter and sprinkle with caraway seeds.

# SHORTBREAD

Shortbread and Black bun (see page 37) are traditionally eaten on Hogmanay, a celebration which originated in France in the 17th century when the two countries were linked in the "auld alliance." Hogmanay is known in parts of Scotland as "cake day."

## SCOTCH SHORTBREAD

4 oz. sieved plain flour    2 oz. rice flour or ground
2 oz. castor sugar           rice
4 oz. butter

Combine flours and sugar in a mixing bowl. Work in butter until the dough is the consistency of shortcrust. Sprinkle board with rice flour. Turn dough on to board and knead till smooth. Cut into portions and shape into rounds. This amount will make four small rounds. Place on greaseproof paper in a baking tin. Prick with a fork. Put in oven at 350°. When the cakes begin to colour (from 20 to 30 minutes), lower the heat. Allow to cool in the tin.

# AYRSHIRE SHORTBREAD

| | |
|---|---|
| 6 oz. plain flour | a pinch of salt |
| 6 oz. rice flour or ground rice | 6 oz. butter |
| | 1 egg |
| 6 oz. castor sugar | 1 tbsp. top of milk |

Mix together the flours, sugar, and salt. Rub in the butter until the mixture is like fine breadcrumbs. Lightly beat the egg and mix with the top of milk. Make a well in the centre of the flour mixture and pour in the egg and cream. Knead with the hand till a soft pastry is formed. Sprinkle pastry board with a little rice flour and roll pastry out thinly. Prick with a fork and cut into rounds or fingers. Place on greased paper a little apart and bake in a moderate oven till golden brown. Cool on a wire tray.

# FORFAR SHORTBREAD

| | |
|---|---|
| 1½ lb. plain flour | 1 lb. butter |
| 3 oz. rice flour or ground rice | 4 oz. castor sugar |

Combine the flours and rub in the butter. Stir in the sugar. Turn on to a floured board. Knead the mixture thoroughly with the hand into a smooth dough. Shape into rounds and notch the edges with the forefingers and thumbs. Bake in a moderate oven (350°) till golden brown.

*Note:* For the rich, unforgettable taste of good shortbread, only the best ingredients should be used—butter in preference to margarine, and the finest plain flour and castor sugar.

# PUDDINGS and PASTRY

## SCOTS MARMALADE PUDDING

4 oz. breadcrumbs
2 cups milk
2 eggs

2 oz. castor sugar
2 tbsps. marmalade

Bring milk to the boil and pour over breadcrumbs. Leave until cool. Separate eggs and beat the yolks with the castor sugar. Add the marmalade and stir into the bread and milk. Beat the egg-whites until stiff, and stir lightly into the mixture. Butter a pudding basin and pour in the pudding mixture. Steam for 2 hours. Serve with custard.

## DRUMLANRIG PUDDING

1 bunch of rhubarb
sugar to taste

½ loaf white or wholemeal
bread

Stew rhubarb with plenty of water and sugar. Put in a pudding basin a layer of bread, then pour on the hot rhubarb. Add another layer of bread and

more rhubarb until the dish is full. Cover with a large plate and leave for 24 hours in a cool place.

This pudding is delicious served with sugar and cream on a hot summer day.

*Note:* Raspberries, strawberries, and currants placed ¼-inch thick in the bottom of the bowl may be treated in the same manner.

## ROTHESAY PUDDING

This recipe originates from the Royal Burgh of Rothesay, sometimes called Scotland's Madeira.

| | |
|---|---|
| ½ tsp. baking soda | 1 dsp. sugar |
| ½ tsp. vinegar | 1 egg |
| 4 oz. self-raising flour | 1 cup gooseberry or |
| 4 oz. fresh white | raspberry jam |
| breadcrumbs | 1 cup milk |
| 4 oz. shredded suet | |

Wet the soda with the vinegar and add to the other ingredients. Mix well. Put into a buttered pudding basin and steam for 2 hours.

## LEMON PUDDING

| | |
|---|---|
| 4 oz. lemon curd | grated rind of a lemon |
| 4 oz. butter | 4 oz. sifted self-raising |
| 4 oz. castor sugar | flour |
| 2 eggs, beaten | milk |

Butter a pudding basin and spoon in the lemon curd. Cream butter and sugar until light and fluffy, then gradually add beaten eggs. Stir in the lemon

rind and fold in the sifted flour. Add enough milk to make a dropping consistency. Steam in a pudding basin for 1½ hours.

## CLOOTIE DUMPLING (1)

| | |
|---|---|
| 1 lb. self-raising flour | 1 apple, grated |
| 4 oz. fresh breadcrumbs | 8 oz. currants |
| 4 oz. sugar | 12 oz. raisins |
| 4 oz. shredded suet | ½ pint milk |
| ½ tsp. salt | 1 tbsp. treacle |
| 1 tsp. mixed spice | |

Mix flour, breadcrumbs, sugar, shredded suet, salt, and mixed spice. Add grated apple, currants, and raisins. Mix well. Stir in milk and treacle until well blended. Scald cloth in boiling water, dust with flour. Place mixture on cloth. Tie securely, leaving room to swell. Have ready a saucepan of boiling water. Place a plate on the bottom of the pan and put the pudding on it. Boil for 3 to 4 hours. Never allow water to drop below half the depth of the pudding. Have a kettle of boiling water handy and add some to the pan about every hour. When dumpling is ready, remove cloth gently and dry pudding off in the oven. Serve with custard if liked.

## CLOOTIE DUMPLING (2)

| | |
|---|---|
| 10 oz. plain flour | 4 oz. shredded suet |
| 1 tsp. baking soda | 2 tsps. mixed spice |
| 10 oz. fresh breadcrumbs | 1½ lb. mixed fruit |
| 8 oz. sugar | milk |

Mix together flour, baking soda, breadcrumbs,

sugar, shredded suet, and mixed spice, then add fruit, mixing in well. Add milk, mixing till well blended. Scald a pudding cloth in boiling water and dust with flour. Place mixture on cloth. Tie securely, leaving room to swell. Have ready a saucepan of boiling water. Put the pudding on a plate on the bottom of the pan. Boil for 3 to 4 hours, making sure that water never drops below half the depth of the pudding; have a kettle of boiling water handy and add some to the pan about every hour. When the dumpling is ready, remove cloth gently and dry pudding off in the oven. Serve with custard.

*Note:* The dumpling can be served next day fried in butter and sprinkled with castor sugar.

## CURRANT DUFF

| | |
|---|---|
| *1 lb. self-raising flour* | *finely grated rind of 1* |
| *6 oz. shredded suet* | *orange* |
| *8 oz. currants (washed)* | *5 oz. castor sugar* |

Sift the flour into a bowl. Stir in suet, currants, rind, and sugar. Mix with enough water to make a dropping consistency. Turn the mixture into a buttered pudding basin and steam for 2½ hours. When ready, turn on to a warm plate and serve with custard.

Serves 6 to 8

## THE FREE KIRK PUDDING

| | |
|---|---|
| *3 tbsps. plain flour* | *3 tbsps. currants* |
| *3 tbsps. sugar* | *3 tbsps. raisins* |
| *6 tbsps. fresh bread-* | *a little orange or lemon* |
| *crumbs* | *peel* |

| 5 tbsps. shredded suet | 1 tsp. mixed spice |
| a pinch of salt | 1 egg |
| 1 level tsp. baking soda | milk |

Combine all dry ingredients, fruit, spice, and peel. Beat the egg and mix with enough milk to make a stiff dough when added to dry mixture. Turn into a greased mould and steam for 3 hours.

## GROSSET FOOL (Gooseberry)

| 1 lb. green gooseberries | 1 heaped tbsp. custard |
| ¼ pt. cold water | powder |
| 8 oz. sugar | 1 heaped tbsp. sugar |
| ½ pt. custard | ½ pt. milk |

Top and tail the gooseberries and cook in the water. When nearly tender, add the sugar. Rub the fruit through a sieve and leave to cool. Make the custard and add to the fruit purée. Beat with a whisk for a few minutes. Serve in individual glasses, topped with whipped cream.

Serves 6

**Custard:** Mix the custard powder and sugar with a little of the milk. Heat remainder of the milk and when it is hot but not boiling, pour on to the blended powder. Return the mixture to the saucepan and stir until the custard comes to the boil.

## SCOTCH TRIFLE

| 1 sponge cake | ½ pt. custard |
| raspberry jam | ¼ pt. cream |
| 1 tin peaches | glacé cherries |
| a little sherry | |

Spread the sponge with jam and put it in a large, clear glass bowl. Drain juice from peaches and mix with a little sherry. Pour over sponge. Arrange the peaches over the sponge. Cover with a layer of custard, then top with whipped cream. Decorate with cherries.

## RHUBARB TART

| | |
|---|---|
| ½ tsp. ground ginger | 2 lb. washed and sliced |
| 8 oz. shortcrust pastry | rhubarb |
| a little icing sugar | 6 oz. castor sugar |

Butter pie-dish and place in it a layer of rhubarb, sugar, and ginger, then put in the rest of the rhubarb, piling it high in the centre of the dish. Roll out the pastry, making it an inch larger all round than the pie-dish. Cut a strip off to cover the rim. Wet the rim with water and place the strip on top. Wet the strip with water and lay on the remainder of the pastry. Make three slits in the centre of the pie. Decorate the edges by pressing with thumb and forefingers. Brush over lightly with milk, or glaze with water and sugar. Bake in a hot oven (425°) for 10 minutes. Lower heat to 375° and bake for 20 minutes more. Sprinkle with icing sugar and serve with cream.

## ECCLEFECHAN (Butter Tarts)

| | |
|---|---|
| 2 eggs | 8 oz. mixed fruit |
| 4 oz. melted butter | 2 oz. chopped walnuts |
| 6 oz. soft brown sugar | shortcrust pastry |
| 1 tbsp. vinegar | |

Beat the eggs, add the melted butter, sugar, and

vinegar. Mix well, then add mixed fruit and nuts. Prepare the patty tins. Roll the pastry out on a lightly floured board to ⅛-inch thickness. Cut into rounds with a fluted cutter. Line the patty pans with the rounds and put a heaped teaspoon of fruit mixture in each. Bake in a fairly hot oven (375°) for 20 to 25 minutes.

Yields 2½ dozen.

## SHORTCRUST PASTRY

*8 oz. plain flour*　　　　*2 oz. lard*
*a pinch of salt*　　　　　*cold water*
*2 oz. margarine*

Sift the flour and salt into a bowl. Rub in the fat with the fingertips till the mixture is like fine breadcrumbs. Add the water slowly to make a fairly firm dough. Turn on to a floured board and knead lightly. Roll out and use as required (and for the two recipes on page 53).

## RICH SHORTCRUST

*8 oz. plain flour*　　　　*1 level tsp. castor sugar*
*a pinch of salt*　　　　　*1 egg-yolk*
*2½ oz. butter*　　　　　　*cold water*
*2½ oz. margarine*

Sift the flour and salt into a bowl. Rub in the fat with the fingertips until the mixture resembles breadcrumbs. Add sugar, egg-yolk, and as much water as is required to mix to a firm dough. Turn on to a floured board and knead lightly. Roll out as required.

## FLAKY PASTRY

    *8 oz. flour*            *3 oz. lard*
    *a pinch of salt*      *a squeeze of lemon juice*
    *3 oz. margarine*    *cold water*

Sift the flour and salt into a bowl. Cream the fat and rub a quarter of it into the flour. Mix to a stiff dough with lemon juice and water. Roll pastry into an oblong and flake a quarter of the fat over two-thirds of the pastry. Fold the pastry in three, first bringing the bottom third up, then the top third down to cover. Lightly press the edges down. Turn the pastry to the left and repeat the flaking process until the fat is used. Leave the pastry in a cool place until it is required.

Always roll pastry lightly and use as little flour as possible on the board and rolling pin.

## ROUGH PUFF PASTRY

    *8 oz. plain flour*    *3 oz. margarine*
    *a pinch of salt*      *a squeeze of lemon juice*
    *3 oz. butter*        *cold water*

Sift the flour and salt into a bowl. Cut the fat into small pieces and stir lightly into the flour. Add the lemon juice and cold water to make a firm dough. Turn on to a lightly floured board. Roll out into an oblong and fold the bottom end one-third up and the top end one-third down. Press the edges lightly with a rolling pin. Half turn the pastry to the left and repeat the rolling and folding process twice more. Roll out again and fold. Leave to cool in the refrigerator. Roll out and use as required.

## MRS DEWAR'S MINCEMEAT

| | |
|---|---|
| 8 oz. currants | 1 tsp. mixed spice |
| 8 oz. seeded raisins | ½ tsp. ground cloves |
| 8 oz. sultanas | ½ tsp. ground nutmeg |
| 4 oz. candied peel | grated rind and juice of |
| 2 oz. almonds | 1 lemon |
| 8 oz. cooking apples | 1 gill brandy or whisky |
| 8 oz. shredded suet | |
| 8 oz. soft brown sugar | |

Wash and prepare the dried fruit. Finely chop with the peel, nuts, and peeled and cored apples. Add suet, sugar, spices, and lemon juice. Mix well, cover, and leave to stand overnight. Stir thoroughly, adding the brandy or whisky.

Pack into dry jars and cover as for jam. Keep for a few weeks and stir well before using.

## JUNKET

| | |
|---|---|
| 2 pt. milk | 2 dsps. rennet |
| 1½ oz. castor sugar | ¼ tsp. nutmeg |

Gently heat the milk until it is lukewarm. Add sugar, stir till it dissolves, then add rennet. Sprinkle with nutmeg. Leave in a cool place. Serve with cream.

Serves 4-6

# MISCELLANEOUS

## PORRIDGE

    *fresh oatmeal*        *rain-water*
    *salt*

For each ½ pint of water, allow a handful of oatmeal and a pinch of salt.

Add oatmeal to boiling water, stirring all the time. Cook slowly for 10 minutes, then add salt. Cook for another 10 minutes. Serve with milk or cream.

*Note:* The Scottish way to serve porridge is with individual bowls of milk, cream, or buttermilk. Take a spoonful of porridge and dunk it in the cream, milk, or buttermilk.

## SKIRLIE

    *beef dripping or suet*    *fine oatmeal*
    *1 onion, sliced*

Melt the dripping or suet in a frying pan. Add the

onion and fry until nicely browned. Now add enough
oatmeal to absorb the fat. Mix well with the onion.
Serve on buttered toast.

## ATHOLE BROSE

    4 oz. medium oatmeal        ¼ pt. whisky
    ½ pt. water                 ¼ pt. cream
    2 tbsps. heather honey

Soak the oatmeal in a bowl with the water for 1
hour. Drain off the liquid and blend in the whisky
and honey, and lastly the cream.

## GRUEL

    fine oatmeal                sugar
    water                       honey or butter
    salt

Steep some fine oatmeal in water for a few hours.
Stir it up and strain to remove the grits. Put into pan
with ½ pint of water and bring to the boil. Boil
slowly for an hour. Add a little salt, sugar, and a
spoonful of honey or butter.

This is an ideal "pick-me-up" for the sickroom, or
on cold winter nights.

## BEEF TEA

    8 oz. gravy beef or juicy   ½ pt. water
        steak                   ¼ tsp. salt, if allowed

Wipe the beef with a damp cloth. Remove all the
fat and skin, then shred finely. Put into a jar or a

double-boiler saucepan with the water and salt.
Cover and stand for half an hour. Place jar in a
saucepan of cold water and bring slowly to the boil,
then simmer gently for 2 to 2½ hours. Remove any
fat and serve hot with sippets of toast.

## MORNING ROLLS

| | |
|---|---|
| *1 lb. plain flour* | *1 oz. yeast* |
| *1 level tsp. salt* | *1 tsp. sugar* |
| *2 oz. lard* | *½ pt. milk* |

Sift the flour into a warm bowl with the salt, then
lightly rub in the lard. In another bowl, cream the
yeast and sugar until liquid. Strain into flour mix-
ture and make into a soft dough with the milk.
Cover with a towel and leave in a warm place to rise
(about 1 hour). Knead lightly, then form into 3-inch
rounds. Brush with milk and dust with flour. Place
on a greased and floured tin and leave in a warm
place for 15 minutes, then bake in a hot oven (400°)
for 15 to 20 minutes.

## STOVIES

It is said in Scotland that if you do not like stovies,
you are not a true Scot.

| | |
|---|---|
| *potatoes* | *butter* |
| *salt* | *water* |

Pick out good quality potatoes. Peel and put in a
saucepan with just enough water to prevent burning.
Sprinkle with salt and small knobs of butter. Cover
tightly and simmer gently until soft and melted.

# MARMALADE

Marmalade was originally made with quinces and first commercially manufactured in Dundee from where it spread in popularity all over Britain.

## SWEET ORANGE AND LEMON MARMALADE

| | |
|---|---|
| 2 lb. oranges | juice of 4 lemons |
| 1 qt. water | 4 lb. sugar |

Wash the fruit thoroughly. Cut the oranges into thin slices and put into preserving pan with the water and let stand for 24 hours. Squeeze the lemons, put the pips into a muslin bag, and put the juice and the pips in with the oranges and boil gently for 1 hour. Remove the pips. Add the warmed sugar, stirring constantly until dissolved. Boil for 10 minutes. Pour into sterilized jars and seal.

## TAIBLET (TABLET)

| | |
|---|---|
| 7 oz. condensed milk | 2 lb. sugar |
| 1 tbsp. butter | 1 cup milk |

Put ingredients into a saucepan and bring slowly to the boil. Allow to boil slowly for a few minutes, stirring occasionally. Test consistency by dropping a little into cold water. When, on testing, the mixture has become like soft putty, remove pan from heat. Beat with a wooden spoon until mixture begins to solidify around the edges. Pour into a buttered tin and mark into bars.

*Note:* 4 ounces of coconut, 2 ounces of chopped

walnuts, or a teaspoonful of vanilla can also be added
for variety.

## TREACLE TOFFEE

| | |
|---|---|
| *4 oz. treacle* | *1 cup cold water* |
| *4 oz. syrup* | *3 oz. butter or margarine* |
| *1 lb. soft brown sugar* | *juice of $\frac{1}{2}$ lemon* |

Place all ingredients in a saucepan and stir over
moderate heat till the sugar has dissolved. Bring to
the boil and boil quickly for 20 minutes without
stirring. Pour into a greased, 8-inch tin and set aside
to cool. Mark into squares and, when completely
cold and set, store in an air-tight jar or tin.

## PUFF CANDY

| | |
|---|---|
| *4 tbsps. sugar* | *1 tsp. baking soda* |
| *2 tbsps. golden syrup* | |

Put sugar and syrup in a pan and bring to the boil,
stirring all the time. Boil for 8 minutes, stirring
occasionally. Remove from the heat and stir in the
soda quickly until it froths. Pour into a well-greased
tin and cool. Break up when cold and store in an
air-tight jar.

## TODDY

| | |
|---|---|
| *a measure of whisky* | *hot water* |
| *brown sugar or 1 dsp.* | |
| *honey* | |

Heat the glass, put in brown sugar and some hot
water. When the sugar has melted, add some of the

whisky, stirring well, then add more hot water and some more whisky. Serve hot.

Traditionally, toddy should be served in a crystal glass and stirred with a silver teaspoon.

*"LANG MAY YOUR LUMS REEK"*

# INDEX